FEED ME with WORDS

A Journey Through Maasai Culture in Batik Paintings

NICHOLAS SIRONKA

AuthorHouse™
1663 Liberty Drive
Bloomington, IN 47403
www.authorhouse.com
Phone: 1 (800) 839-8640

Published by AuthorHouse 03/07/2017

ISBN: 978-1-5246-7227-0 (sc)
ISBN: 978-1-5246-7228-7 (e)

Library of Congress Control Number: 2017903231

authorHOUSE®

Contents

Feed Me with Words

I am Nicholas Sironka, a Maasai from Kenya and a resident of Spokane, Washington. I have a God-given talent in art. With this art, and my knowledge of my Maasai culture, I have sought for many years to help create an awareness and greater understanding of the Maasai through lectures, presentations, and my large batik paintings.

My philosophy is that if I can use my talents to touch another life and make it better, then I will be fulfilling the purpose for which God put me on this earth.

I use my art and culture presentations to reach out to others, not just to create awareness of Maasai culture, but in the process, to help make this world a better place for all.

I also enjoy telling stories to the young.

The Maasai believe that words are nourishment for the spirit. Words can build and words can heal. This comes from the body and from within!

My paintings in this book originate from many of my past art exhibitions and seek to celebrate life!

The Maasai....
..."My people, My Pride!"

Many years ago my wife urged me to never give up!

Seleina is no longer with us but will forever be with me in spirit.

I dedicate this book in memory of

My best friend

My soul mate

My wife

Seleina.

A Gift from God

To the Maasai,
children are a gift from God.
Children must be loved.
Children must be cared for.
Let us love one another
like children.
Let us be thankful
like children.
And in our hearts,
let us have pure thoughts,
like children.
For when we do,
we will make this world a better place
for us all!

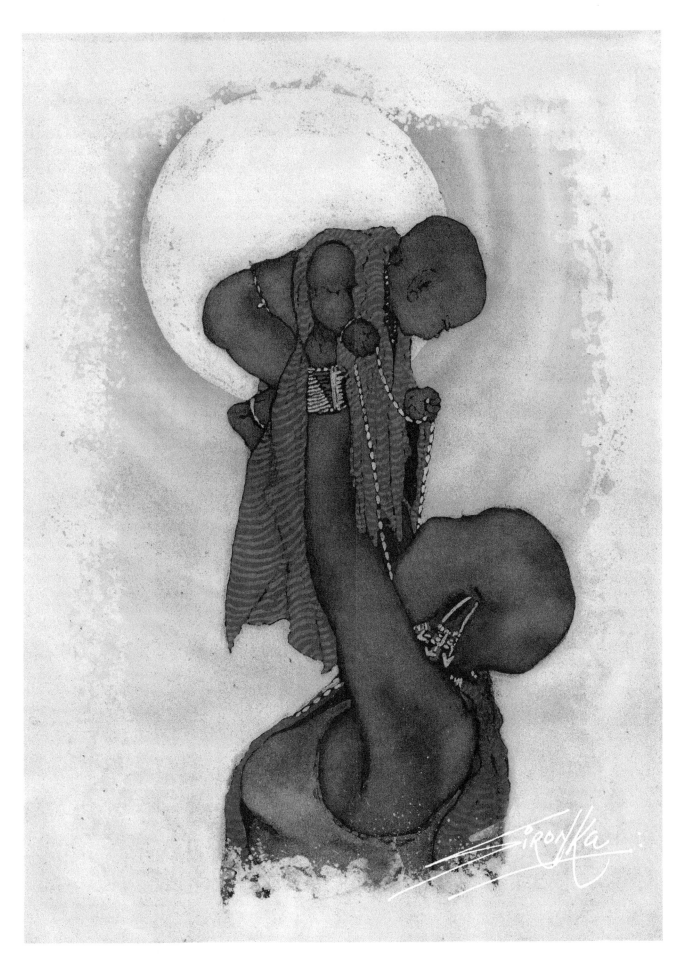

A Mother's Love

It has been said that the pain of a child is best felt by a mother.
If the Maasai had a choice between having cattle and having children,
they would choose having children.
A child born to a Maasai family is a welcome gift to an entire village!
There is always someone watching and learning.
They are learning a lesson that only a true mother can give.
It is the most unique lesson of all.
It is a lesson felt throughout one's life.
It is a lesson only a mother can give.
It is a mother's love!

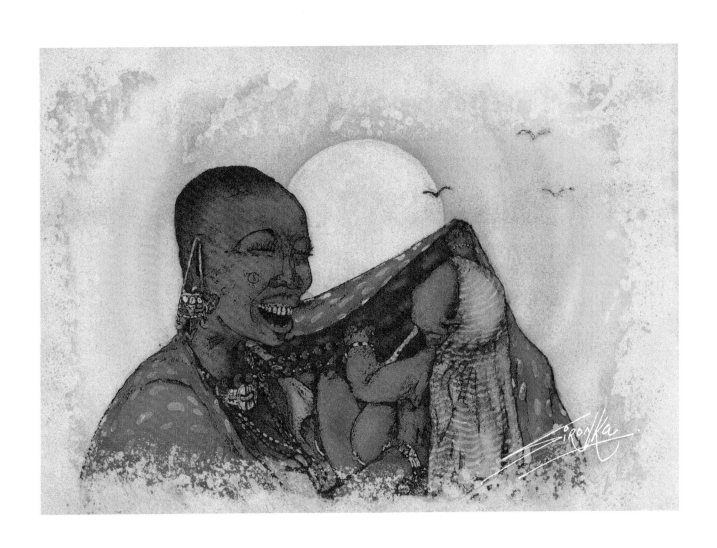

"Netii-opa" – Once upon a time (Storytelling)

When she was a little girl,
her mother sang the same song to her.
She told her the very same story!
And many years later,
now a mother herself, she quietly sings that very same song.
She quietly tells the same story.
Soon her young ones will also go to sleep.
As in many cultures around the world,
storytelling is a part of life for the Maasai,
a much welcome ritual
before the children go to sleep.
It is soothing to the spirit.

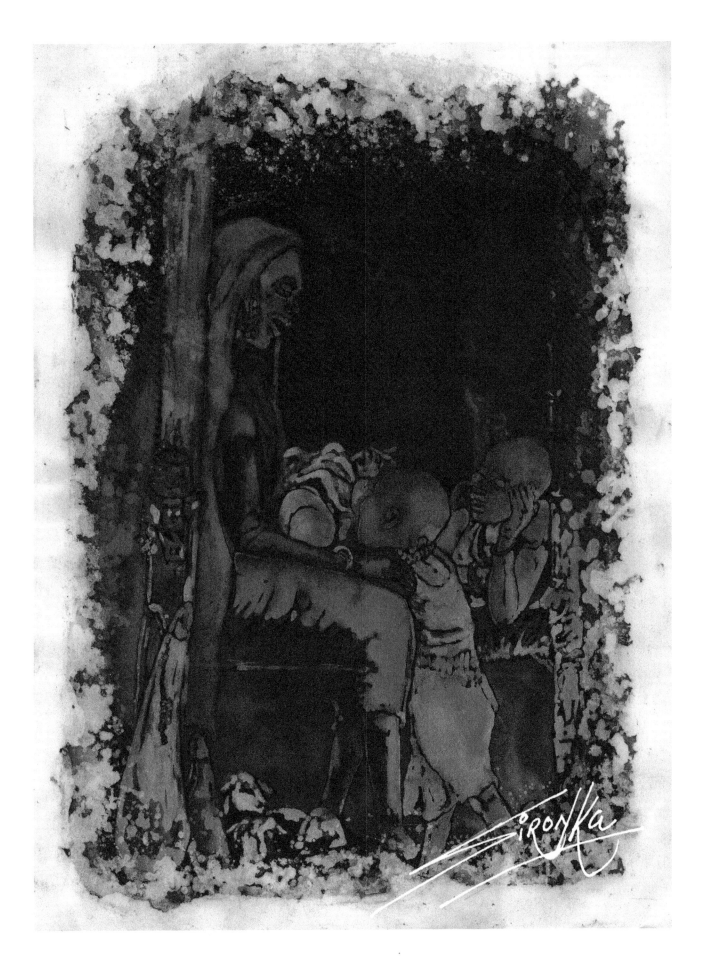

And How Are the Children?

As a greeting to one another, the Maasai will say
"Peace be with you!"
It is a salutation that is promptly followed by a question:
"And how are the children?"
When children are happy, the entire village is happy!
When children are not well,
the entire village is not at peace.
Let us love our children,
for they are a gift from God.
Their trials must be our trials,
and their happiness
is our happiness!

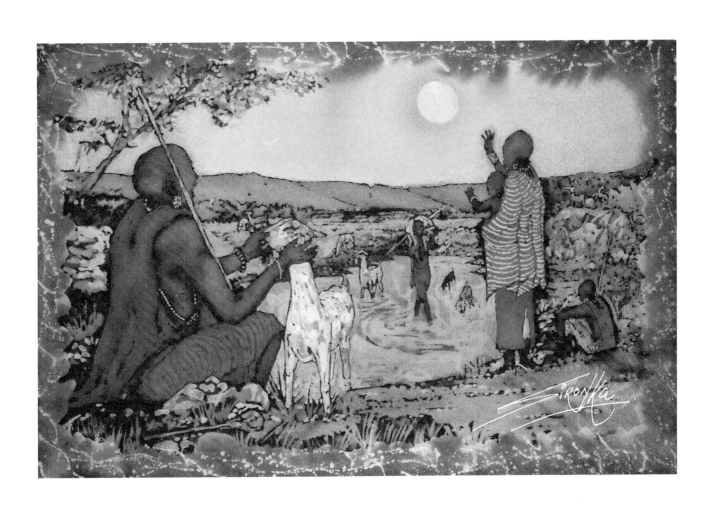

A Little Boy Wanders Far from His Home

Once upon a time, in a Maasai village,

A little boy was home with his mother as she went about her morning chores. His mother, like many mothers, kept a close eye on him and once in a while would shout out his name. With Her son's responses, she was continually aware of his whereabouts in the big homestead.

"Loishorua, koree iyie?!" My Blessing, where are you?!" his mother calledout.

Little four-year-old Loishorua would shout back and respond politely "Nele nanu!" "Here I am!"

Then there was silence.

From time to time this silence would be interrupted by his mother's call.

Soon however, Loishorua's mother's domestic chores got the better of her and she did not call out for her son for a prolonged period of time.

Meanwhile, Loishorua fascinated by his shadow, determined to catch up with his shadow!

"I can run faster than my shadow if I can just step over the shadow of my head!" he thought.

With excitement little Loishorua would jump, run, walk, and jump again! Then he would run fast again, always trying to go over his shadow... Over his head!

Soon little Loishorua was out of the homestead!
Without realizing it, soon Loishorua was far away, far beyond where the eye could see!

Loishorua was a little boy, a little boy who had wondered far from his home!

"Oo-Loishorua!... Loishorua?!" His mother called, her voice growing louder.
"Where could he be?" she wondered.

She searched in her house and in the surrounding houses. Her son was nowhere to be found!

She stopped all of her work and decided to walk over to her sister's house a half mile away. In doubt that her little boy would walk that far from home, she thought this was the only possible place he could have gone to on his own!

Or did her sister Naserian, who was always playing tricks on her and had a great love for Loishorua, come and sneak him away to her house?

But to her disappointment, neither her sister nor anyone in Naserian's homestead had seen Loishorua that morning!

Something was amiss! Where was Loishorua?!

Loishorua was nowhere to be found.

The Maasai have a saying, "every child is my child!"
And soon a great search for Loishorua ensued.

All day the villagers searched.
Loishorua could not be found!

They looked everywhere.

Just as the sun was setting little Loishorua's father returned home with his
herds. The news of his son's disappearance was an unbelievable tale!
But with the maturity of a Maasai shepherd, he chose to take the news with
sobriety and wise deliberation, rather than with the impulsive reaction of
most young men.
With a voice of reason he told Loishorua's mother to have faith.

"Weep not. Be strong. We will find him." He reassured her.
But deep inside, Loishorua's father could only hope. He said a silent prayer,
prayer of hope.
He knew that they needed nothing short of a miracle! How could a small
boy just vanish?
It had never happened before.
Never!

Soon day turned into night!
Then night turned into day. It was now evident that an entire village had
been turned into one big search party!

Early the next morning Loishorua's father and the entire village went out
again. They went out in search of their son!

Another day, and another night!
It slowly became evident that some of the villagers were giving up.

It was the third night!
A million stars lit the dark African skies.
Loishorua's father and the other villagers sat in silence around a big fire.

When suddenly the sound of a lion's roar pierced the silence!

An entire village was shaken.
What was a lion doing this close to their village?!

How could this be?
Lions have not been seen or heard of in these parts for generations!

All hopes of ever finding the boy were now lost!
Looking up into the dark skies, little Loishorua's father silently whispered
a solemn prayer.

At first light, Loishorua's father met with the other villagers to determine
a search plan. As expected, everyone had something to say about the roar
of the lion that had come so close to home.
"We must be very careful" Loishorua's father emphasized.
He did not want any of his neighbors to lose their lives.
Looking at the young men he said.

"My sons, you must heed my advice.
You must now follow me."

Soon they all headed out towards the direction the lion's roar had come
from.

With the young men armed with long shiny spears by his side, Loishorua's
father slowly trekked towards the hills.

They went up the winding path.
Up into the thickets. Up towards the hill.

Suddenly all stood still.
Loishorua's father could not believe his eyes.

Hoping that his eyesight was not playing with his mind, Loishorua's father saw from a little distance ahead, a little boy joyfully walking towards them.

It looked like Loishorua!
Was this his son?

"This cannot be!" He exclaimed.

But indeed it was.
It was Loishorua.
It was his four-year-old son coming home!

Loishorua's father ran towards his son.
Everyone ran.

Amidst tears of joy, Loishorua's father shouted a loud prayer of gratitude to God.
He embraced his son. Lifting him up and squeezing him tightly, he wept aloud.

"My son! My son!" he exclaimed amidst great sobs.

The news spread fast, and soon Loishorua's mother arrived.

On seeing her son she was breathlessly in shock. She too could not hold back her tears of joy.

Her legs gave way as she fell to the ground!

Seeing her son overwhelmed her.

All the young men and the women around him wept tears of joy. Each wanted to hold and embrace the little boy. All of a sudden their celebrations were interrupted by the appearance of a male lion!

With a huge menacing frame, the lion paced up and down a short distance away!

Instinctively, the young man reached out for their spears.

"No!" shouted the boy's father, as he ran before them!

Raising his hands to the sky as he shouted,

"That is not your enemy!

"That is not your enemy!

"That is not my enemy!"

"If not for that lion, we would not have my son here and alive again!

"You will not kill him!"

"No. Instead, I say to you, go and bring my biggest bull!"

The young men obeyed. And soon the man's favorite and most beautiful bull, a bull that was the talk of the land was brought forth. He asked that it be butchered as a gift of gratitude for the lion.

Looking towards the lion that was now laying down, Loishorua's father shouted out,

"Thank you my friend!"

"This is for you!" he went on as he pointed to the now butchered bull.

"Come, eat, and know this day that I appreciate you!"

"God has used you, and my son is home again. Thank you!"

Having said this, Loishorua's father asked the villagers to head back home.

He no offered another bull for his neighbors and friends as an offer of gratitude to them for all their efforts to help search for his son.
As is the normal practice, the young men burst out in song.
For this was the way of the Maasai.
Every good thing, every landmark event was a new song, a song about our time!

But another surprise awaited them!
As they glanced back from time to time to see the lion's response to their offer of gratitude, they were taken aback when suddenly from within the bushes, a pride, most likely the lion's family came out from behind the thickets!

The pride of lions along with a lioness and her cubs joined the male lion.

They came to feast on their reward!

A just reward indeed!

A reward for bringing back a little boy.

A little boy who wondered far from home.

A story by Nicholas Sironka.
A story based on real life experience.

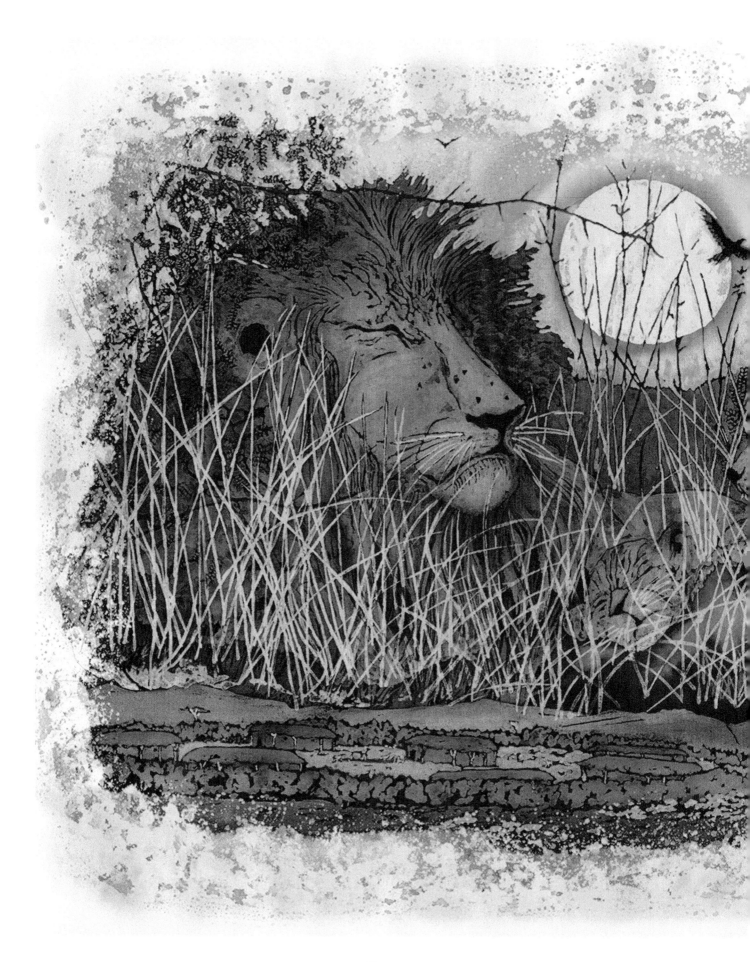

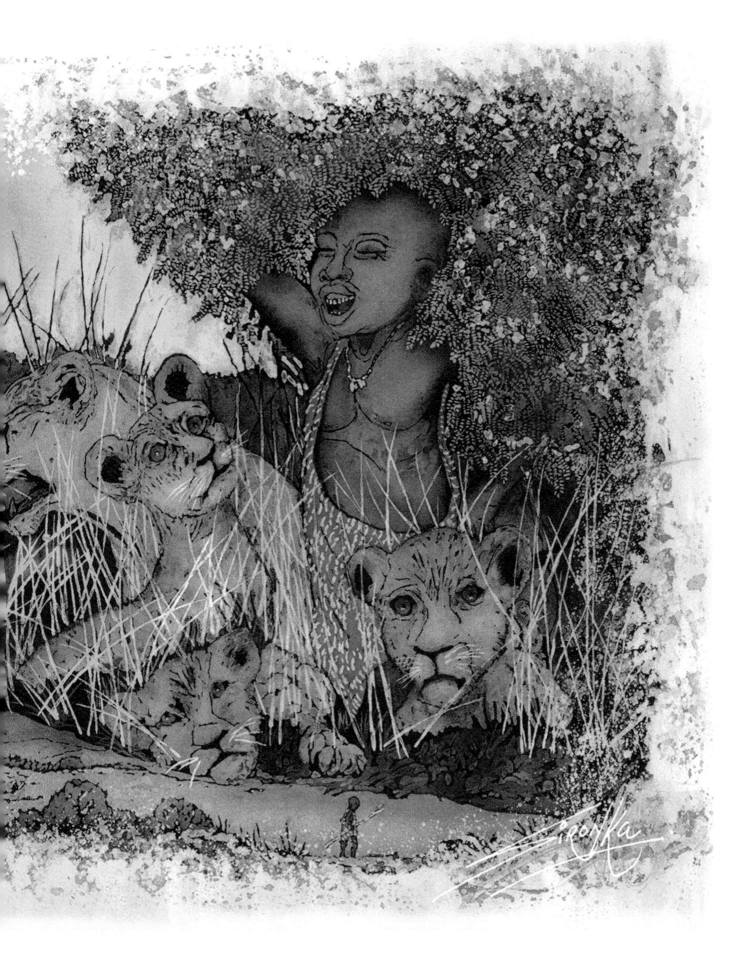

All Children Are Our Children

"We have given birth!"
This is the shout of the women in a Maasai homestead when a woman gives
birth.
While many would celebrate increased wealth,
the Maasai celebrate the birth of a child.
The birth of a child by any one of them is the birth of a child to all of them!
A woman's worst fear is the inability to bear children!
And so, it is not strange to see a woman, unable to have children,
being given a child by another to fill that void.
To complete her state as a woman, she desires motherhood!
For this reason, "We have given birth!" justifies the proclamation,
"All children are our children!"

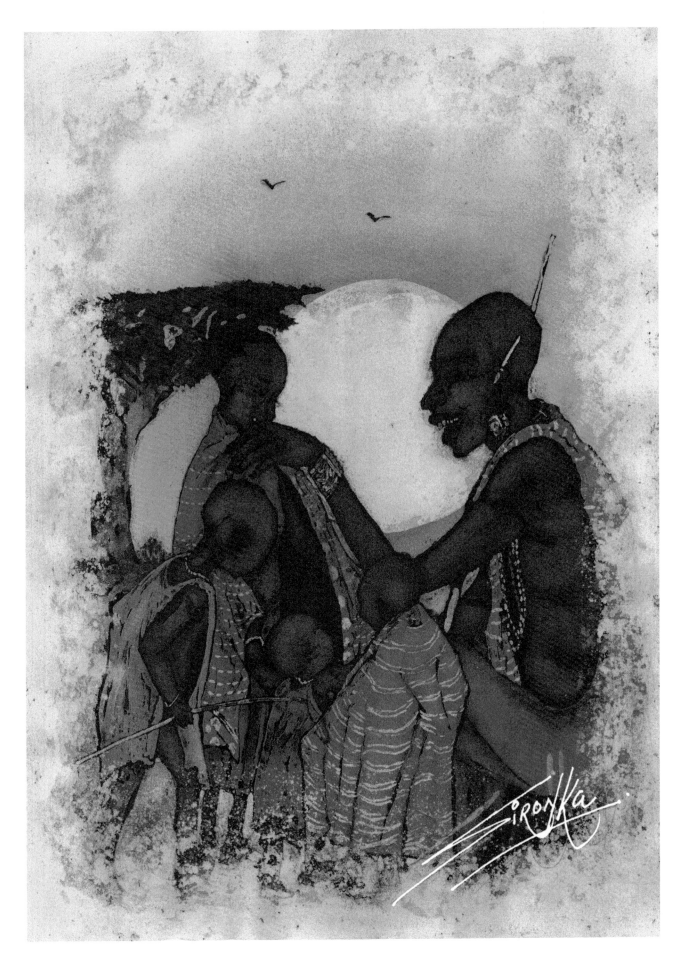

In the Beginning

The Maasai and wildlife
live side by side.

They celebrate life one day at a time.

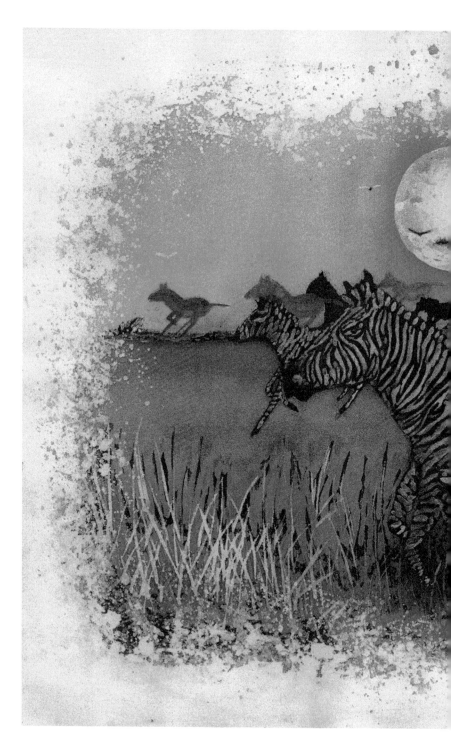

As it should be for you and I,
let us forget our differences.

Let us see

Eye to eye!

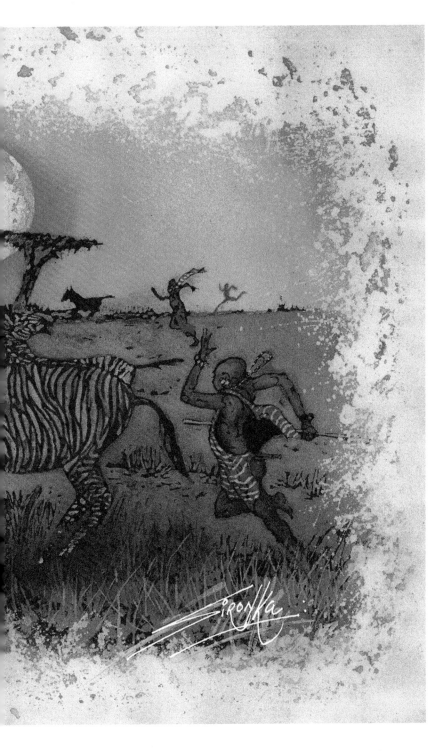

24

A Warrior's Song

Maasai warriors are the most adorned and most beautiful people to behold.
Their songs and high leaps in rhythm are the climax
of any Maasai celebration.
They compete to see who jumps the highest.
It is unique way to impress the young girls!
They celebrate competition.
Let us celebrate competition in the same spirit.
In doing so, we will only better ourselves in all that we do.

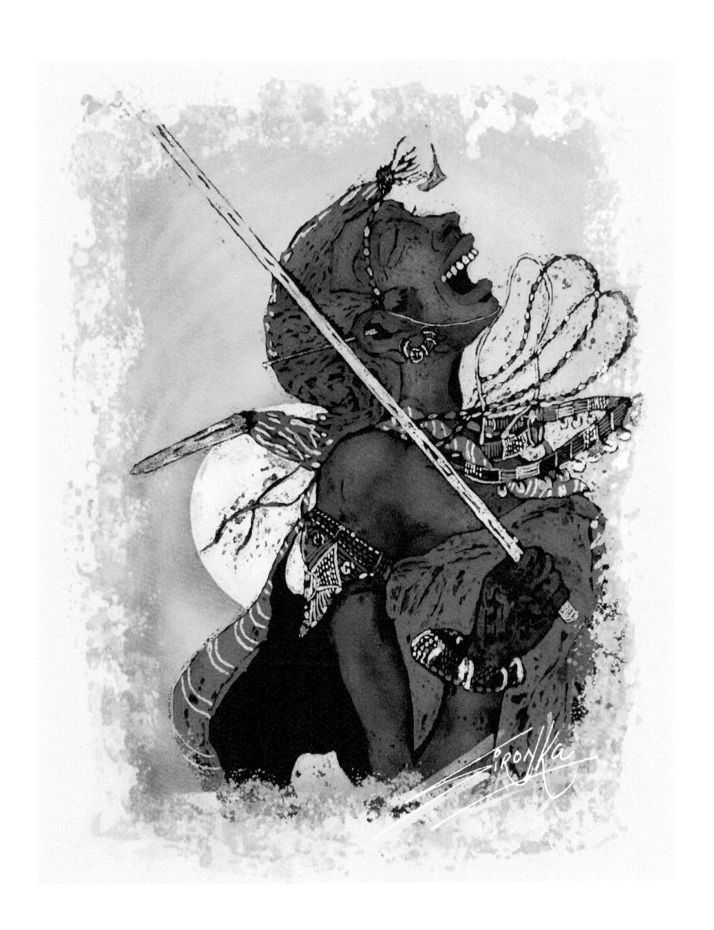

Another Song for My Warrior

Becoming a warrior is the stage between being young shepherds and elders.

Warriors are fearless, proud, and a symbol of the Maasai strength.

The bravest warrior is appointed to be the symbol of strength for his regiment.

He puts himself in harm's way every time they go to battle!

While many would celebrate such warriors as heroes, a mother will quietly worry over the safety of her son.

And at the end of every expedition the warriors will stream back home in song.

A mother's worst fear is to not see her son return home.

And even in his absence, a fallen warrior will be celebrated in song.

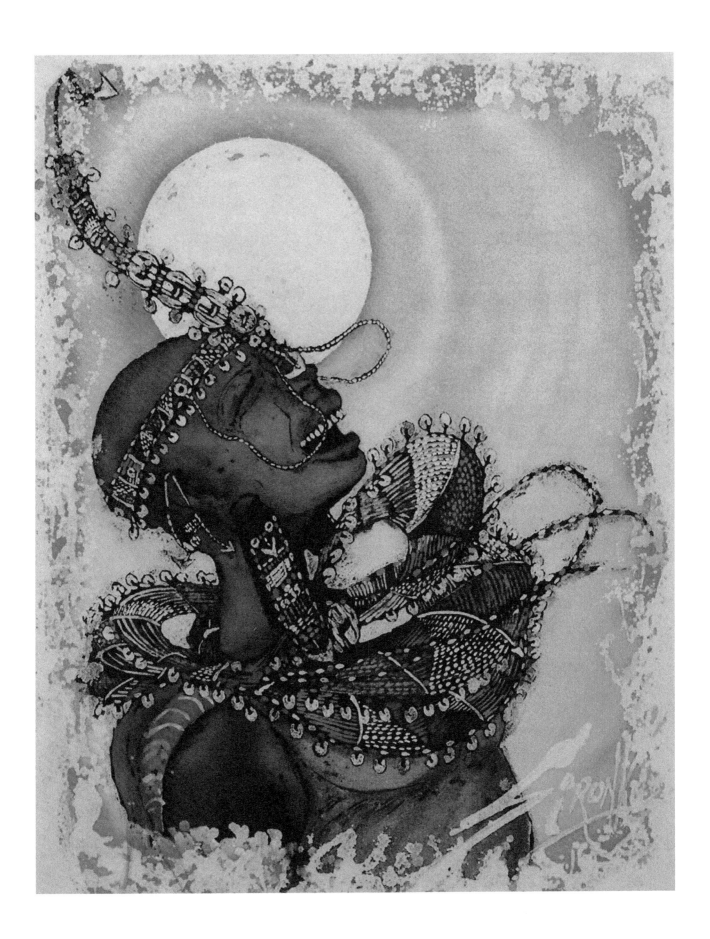

A Song from the Past

Maasai warriors are the most adorned and most beautiful people to behold.

Their songs and high leaps in rhythm with their songs are the climax of any Maasai celebration.

They compete to see who jumps the highest.

As is the normal practice, the young men burst out in song.
For this is the way of the Maasai.
Every good thing, every special event is a new song.
It is a song about our time!

It is a unique way to impress the young girls!
They celebrate competition.
Let us celebrate competition.
In doing so, we will only better ourselves in all that we do.

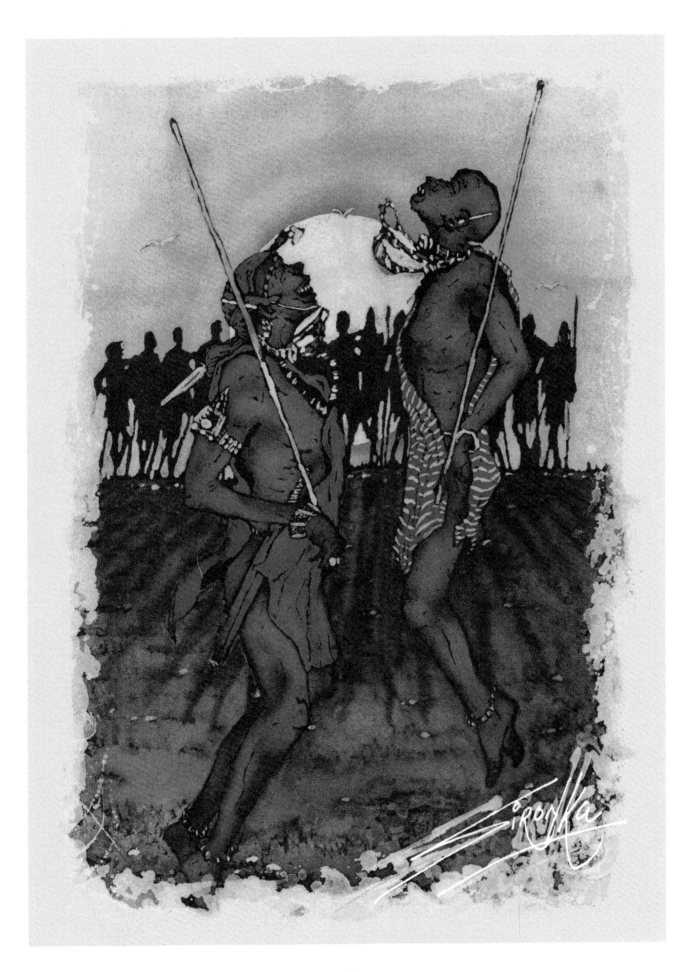

Feed Me with Words

When two Maasai meet, their salutation will be "Peace be with you!"
This is promptly followed by "Feed me with words!"
Each will then take time to slowly tell the other about his family while paying special attention to the wellbeing of their children, the weather back home, their cattle, sheep and goats, and even how their neighbors are faring. Nourishing each other with words.

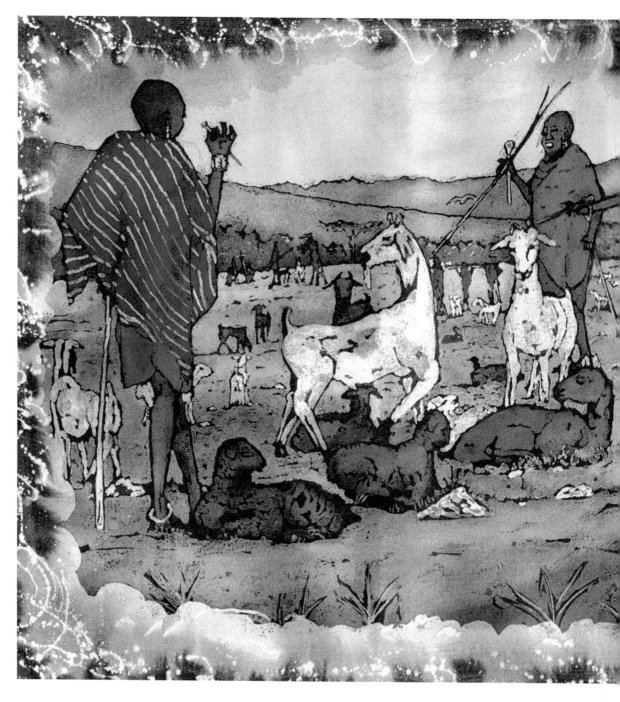

Having fed each other with their words, they will then go on to discuss that which has brought them together.

On this day, it is the buying and selling of goats!

Let us feed each other with words, words that bring joy to the heart, words that nourish the spirit.

And let us take time to also listen to one another. For when we do, we will make the world a better place for all of us!

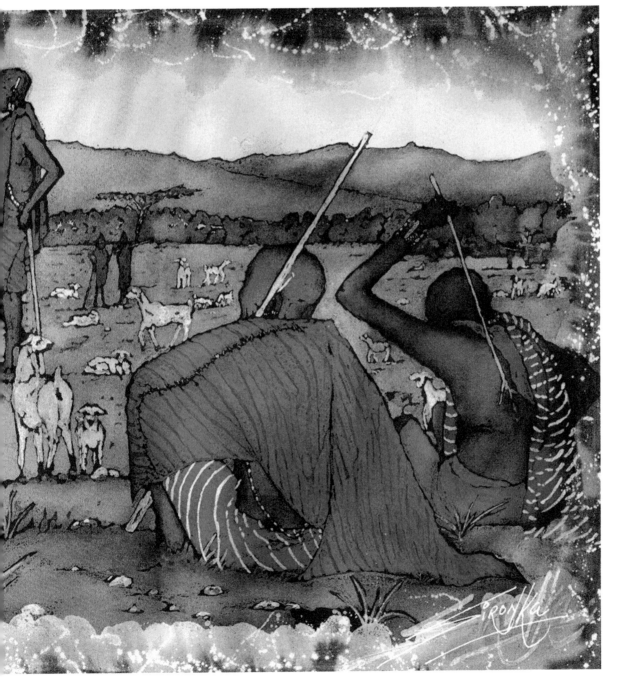

"Olen-goti" -Keeping watch

When the Maasai skies are darkened heavy rains fall.

Their cattle-pens are drenched and the ground they lie on soaked.

Being aware of this, in the darkness of night a good shepherd will drive his herds out to higher ground.

He does this so they can sleep.

Leaving the comfort of his home, his wife and children, the herdsman will set aside his personal comforts for the sake of his herds.

Now his cow can sleep, while he stays awake all night!

A rare sacrifice indeed!

Let us be willingly sacrifice what we prefer for ourselves, for the sake of those we love!"

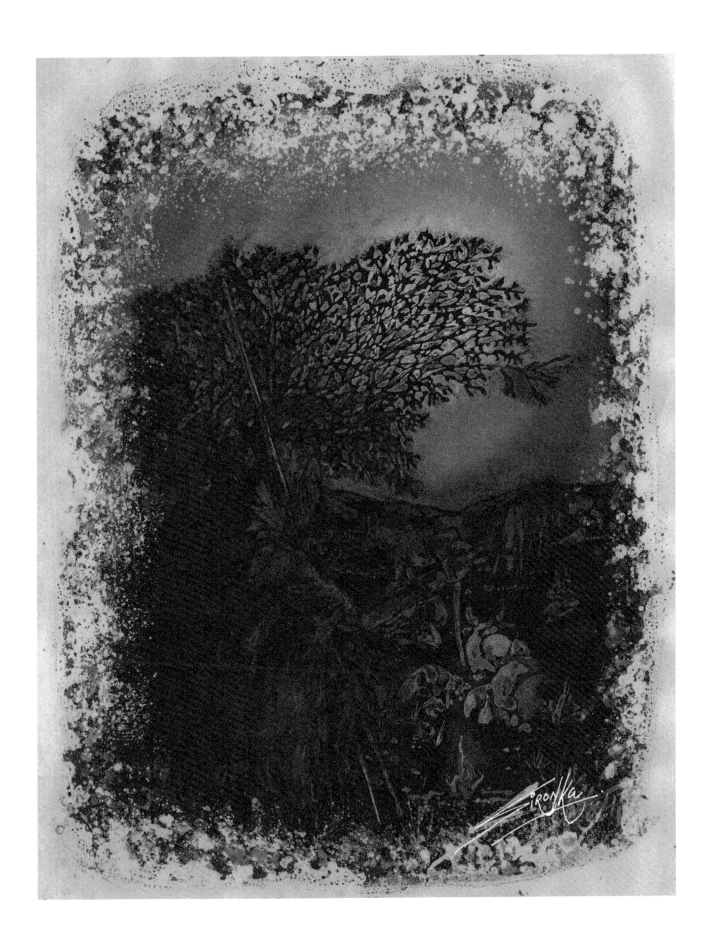

Impulsive Reaction or Wise Response

When I was a warrior my spear was my friend.

Each day that I grew stronger, courage became my guide.

But now that I am older, a staff is in my hand.

With deliberation and caution as a shepherd,
I know!

That in the face of adversity,

Impulsive reaction
Or
Wise response?

A future
in time
My choice will unfold!

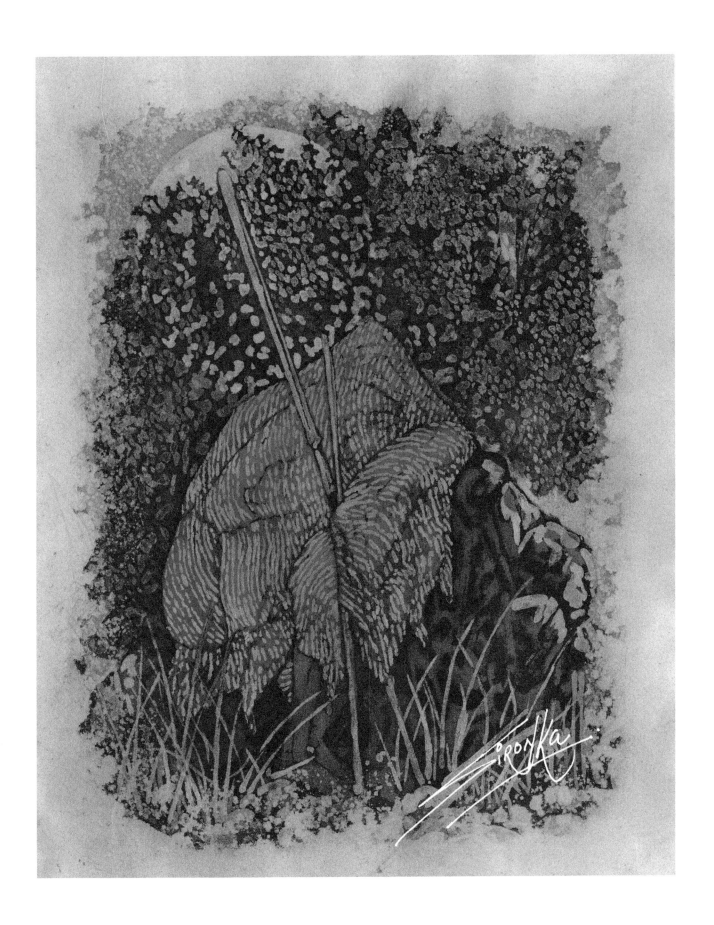

The Ultimate Warrior

Becoming a warrior is a dream for every Maasai youth.
This stage in life represents strength, courage, confidence, and an eloquence
in song.
A warrior's comradeship is many times symbolized by the markings on his
shield,
the markings of his regiment,
the mark of his bravery.
This is the mark of the ultimate warrior!
It is an expression of the ultimate best!

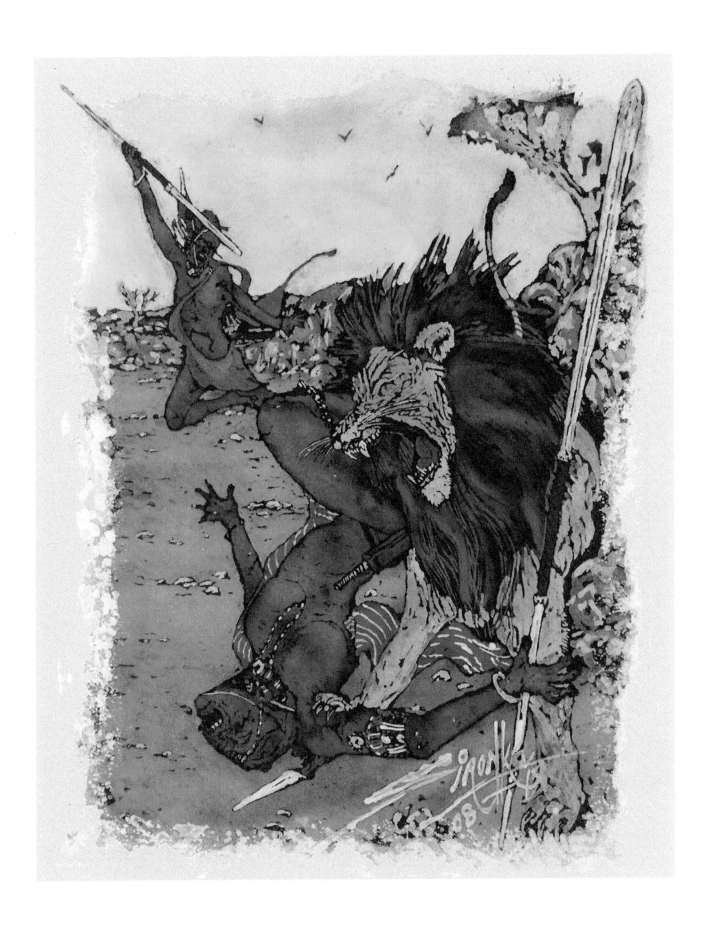

A Long Way From Home

The Maasai are pastoralists.
Mythology and anthropology suggests that this is what
they have been from the beginning of time.

They move their cattle from place to place in search of
green pastures.

By day and by night, they will search the vast grasslands,
taking turns to sleep,
as the shepherds watch over their herds.

And though their quest for good pasture may take them
far away from home,

the Maasai have a saying,

one that always gives them hope

"Home is never far while you still live!"

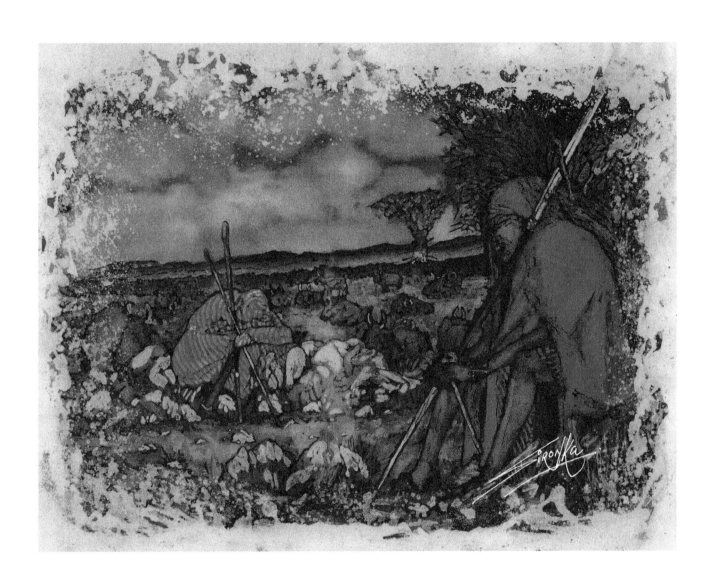

Pillars of Wisdom

To be a Maasai elder is a dignified stage in a man's life.
Elders are well known for their serious discussion gatherings,
an open forum known as "Enkiguana".
They will arbitrate on issues such as murder, divorce, and theft.
An elder's eloquence and the proper use of proverbs and sayings
to deliberate on issues,
will help win the forum's consensus.
But rarely are women given credit for their input.
Men will many times have already conferred with their wives at home!
They will be celebrated as beacons of wisdom
while their wives will many times be dismissed as "just women."
Justice is humane, practical, and fair.
These are the virtues that the women have always been known to uphold.

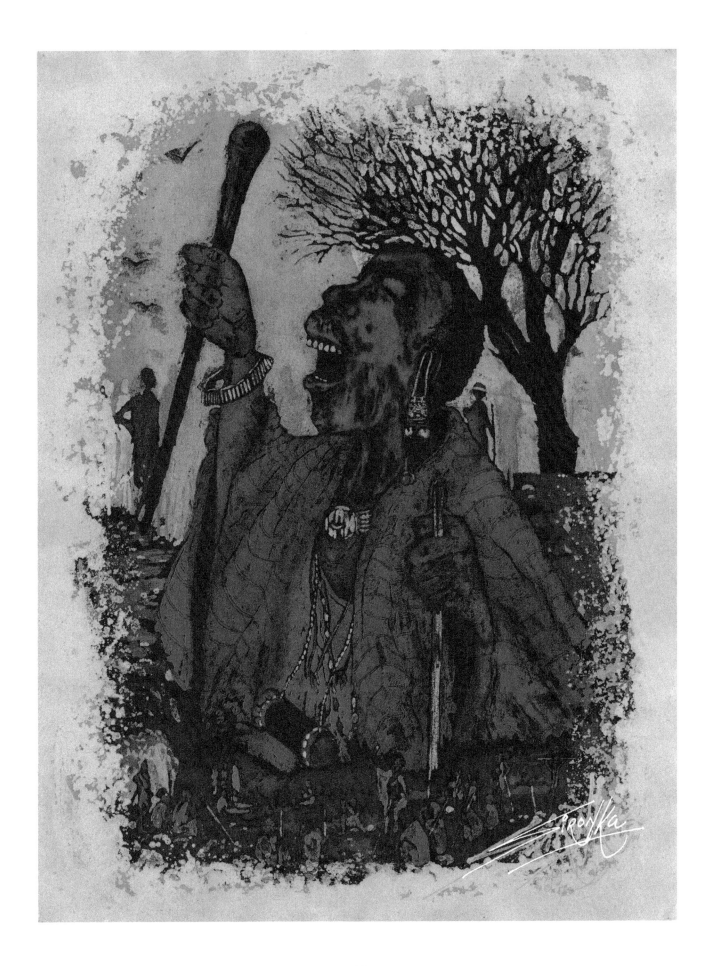

Forever Young

Maasai women are known to love deeply.
With humility, they love their husbands, their children, and their roles as
the backbone of every home.
They love
not because of appearance,
but for something much deeper within.
It is something unseen, something pure, and something indescribable.
Often our women live long and happy.
Time spent with their children
seems to regenerate their lives.

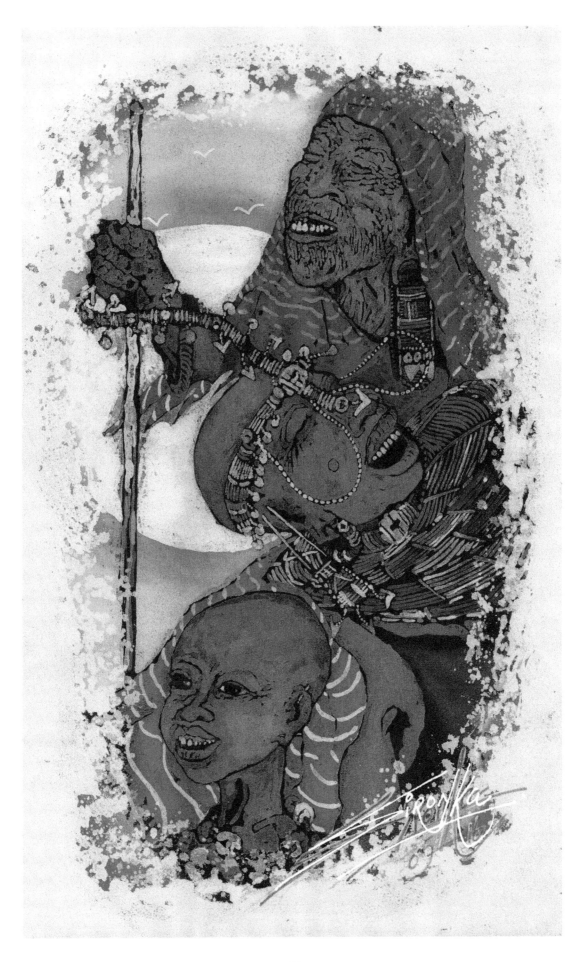

Exodus

The Maasai are pastoralists. Mythology suggests that they have always wandered from place to place in search of green pastures and water for their herds.

They have learned to be good shepherds who are able to read the signs in their skies to know the language of the weather. To be a good son, you also had to be a good herdsman.

For when the time came, one's family would very much depend on it!

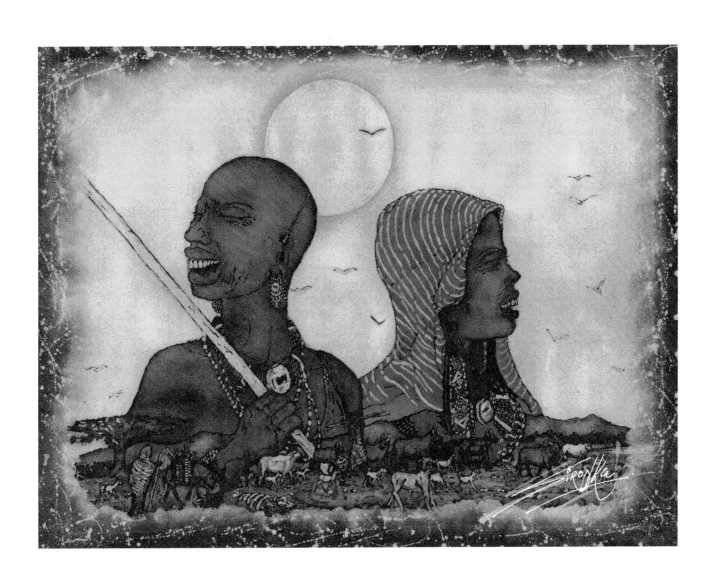

I thank God for His love, and for turning my
hope into a real and tangible reality.
Thank you my good friend Jesse Swanson for the many hours
you spent patiently scanning, and arranging all my images, and
ensuring that I was working within the time frame that worked
for both of us. In working with you, I am most fortunate to be
working with one of the very best in his field of work!
I wish to thank my son Koinet, and my daughter
Sision for never giving up on me!
Thank you Michael Lindenmuth for your patient editing
and for turning my draft into readable reality.
Thank you April Roma, for breathing life into my
work with your design and talented input!

CPSIA information can be obtained
at www.ICGtesting.com
Printed in the USA
LVOW05s1417060517
533509LV00025B/161/P